COASTAL SHIPPING
THROUGH TIME
Ian Collard

AMBERLEY

First published 2016

Amberley Publishing
The Hill, Stroud, Gloucestershire, GL5 4EP
www.amberley-books.com

Copyright © Ian Collard, 2016

The right of Ian Collard to be identified as the
Author of this work has been asserted in accordance with
the Copyrights, Designs and Patents Act 1988.

ISBN 978 1 4456 5881 0 (print)
ISBN 978 1 4456 5882 7 (ebook)

All rights reserved. No part of this book may be reprinted
or reproduced or utilised in any form or by any electronic,
mechanical or other means, now known or hereafter
invented, including photocopying and recording, or in
any information storage or retrieval system, without the
permission in writing from the Publishers.

British Library Cataloguing in Publication Data.
A catalogue record for this book is available from the
British Library.

Typesetting by Amberley Publishing.
Printed in Great Britain.

Introduction

Britain has always been an island nation, and for hundreds of years, its trade was mainly carried by sea. Raw materials, farming produce, food, animals and finished products were all transported by coastal ships and barges, which also carried goods being transhipped from around the world. It was claimed that one of the major achievements of the eighteenth century was the creation of well-maintained roads. These roads helped to facilitate the transportation of goods and passengers, which was also a contributory factor to reducing costs and forming an integrated market. However, the roads were not planned centrally and were a result of local enterprise and initiative. They were regulated by Acts of Parliament, and local organisations were given the power to levy tolls on users. The profits made were used to maintain and improve the turnpike roads, which began to decline with the coming of the railways, and the Local Government Act of 1888 gave responsibility for maintaining the roads to county councils and county borough councils.

However, sea transport has always been the largest carrier of goods, and virtually any material can be moved by water. Although Europe is the world's second smallest continent in terms of area, it has a very long coastline and is situated between several navigable seas, intersected by navigable rivers, which facilitated the influence of traffic and commerce. Although Britain is an island, the proximity to the mainland of Europe enabled coastal vessels to trade with ports on foreign coasts. This coastal trade had been in operation since Roman times and included corn, tin, lead, salt, livestock, earthenware and timber.

From the fifteenth to the eighteenth centuries, sea travel was dominated by sailing ships, which were dependant on the weather and the winds. The first steam engines appeared at the end of the eighteenth century, and these were developed to be more economic and efficient with the steam driving a propeller or paddle wheel. The new steamships gradually replaced sailing ships for commercial shipping through the nineteenth century, with William Symington's *Charlotte Dundas* being generally considered the world's first steamboat when she made her first voyage in 1803. In 1819, the *Savannah* was the first vessel to cross the Atlantic partly under steam power, and in 1838, Isambard Kingdom Brunel's *Great Western* was the first purpose-built transatlantic steamship, when she inaugurated the first regular transatlantic steamship service. Charles Parsons's *Turbinia* was the first vessel to be powered by a steam turbine.

The collier *Bedlington* was built in 1842 to carry coal from Blyth to the River Tyne. She was fitted with a screw propeller and was the first iron-screw collier. The *Q. E. D.* was a sailing vessel, which was fitted with a screw for auxiliary power, and she was the first vessel to be fitted with a double bottom for water ballast. The *John Bowes* was an iron screw collier that was built on the Tyne in 1852 for the coastal trade to London and was still in service in the 1930s. The steam turbine was introduced in the passenger coasters *King Edward* and *Queen Alexandra* in 1901 and 1902 on the Clyde, and the geared turbine was applied to *Hantonia* and *Normania* in 1911.

The coastal services provided by Coast Lines can be traced back to the early nineteenth century when small sailing ships provided a service for merchants between London and Liverpool. Coast Lines was formed on Merseyside in 1913 by the merger of Powell, Bacon and Hough lines. On 30 September 1913, the three lines were merged and incorporated as the Powell, Bacon & Hough Lines Limited. The fleet consisted of *Powerful, Cornish Coast, Faithful, Sussex Coast, Dorset Coast, Graceful, Norfolk Coast, Hampshire Coast, Stonehenge* and *Hopeful* from Powell's. *Edith, Sir George Bacon, Sir Edward Bacon, Sir Roger Bacon, Sir Walter Bacon* and the barges *Harfat* and *Pennar* came from the Bacon Line, and the *Annie Hough* and *Dorothy Hough* from Hough's. The total ships' tonnage was over 16,000 tons, and the name was changed to Coast Lines Limited in May 1917, becoming a public company in June 1919.

The company was acquired by the Royal Mail Line in March 1917 for £800,000, with Sir Owen Phillips as its Chairman and Alfred H. Read as Managing Director. The shareholdings were distributed in preference and ordinary shares in the Royal Mail Line, Elder Dempster & Company Limited, Union Castle Line,

McGregor, Gow, Norris & Joyner Limited, Lamport & Holt Line and James Moss & Company Limited. Sir Alfred Read had purchased shares in the British & Irish Steam Packet Company Limited in 1914, and in 1918/19, he gained a controlling interest in the City of Dublin Steam Packet Company Limited and the City of Cork Steam Packet Company Limited. The City of Dublin Steam Packet Company Limited withdrew their services from the Liverpool–Dublin route in 1919, and when it lost the Holyhead–Dun Laoghaire mail contract in 1920, it went into liquidation in 1924. The City of Cork Steam Packet Company Limited was finally merged with the British & Irish Steam Packet Company Limited in 1936, but the vessels retained their funnel colours.

In 2013, the number of international short sea ferry journeys increased by 4 per cent to 20.5 million following two years of decline. Dover remained the busiest seaport in the United Kingdom, carrying 12.7 million international short sea ferry passengers. This was a 7 per cent annual increase, but remained 20 per cent lower than ten years previously. In 2012, more passengers travelled internationally via the Channel Tunnel than ferries for the first time. However, in 2013, ferries accounted for 1.7 million (9 per cent) more international journeys than the Channel Tunnel. Passenger traffic on domestic sea crossings has steadily declined over the past decade. The number of passengers travelling by ferry from Great Britain to Northern Ireland and the Channel Islands increased to 2.1 and 0.4 million, respectively.

The total number of international short sea passengers travelling through British ports decreased by 1 per cent from 21.3 million in 2014 to 21.0 million in 2015. Passenger numbers at Thames and Kent and West Coast port groups declined by 2 per cent. Dover–Calais remained the busiest short sea route handling 47 per cent of all international short sea passengers, but declined by 9 per cent to 9.8 million compared with the previous year. The volume of international short sea passengers on the Dover–Dunkirk route increased by 27 per cent from 2.5 million in 2014 to 3.2 million in 2015. In 2015, the number of passengers travelling via the Channel Tunnel decreased to 20.9 million, which is marginally fewer than the number of sea passengers.

Since opening in 1994, the trends in the number of passengers travelling by the Channel Tunnel and by sea have steadily merged. France remained the most popular country of destination, with the Irish Republic being the second. Passenger numbers on the Holyhead–Dublin route increased by 5 per cent to 1.9 million compared to 2014. Passenger numbers on the Harwich–Hook of Holland route have grown year on year since 2012. In 2015, these numbers rose by 15 per cent to 0.7 million. In 2015, traffic between the United Kingdom mainland and Northern Ireland decreased by 3 per cent to 2.0 million passengers. Cairnryan–Belfast remained the most popular route with 1.1 million passengers, a similar number to the previous year. Traffic between the United Kingdom and the Isle of Man decreased by 1 per cent to 0.3 million. Overall, the number of journeys between the United Kingdom mainland and the Channel Islands decreased by 13 per cent to 0.3 million. (Source: The Department for Transport)

Above: *King Orry* (1842/433 grt.). Isle of Man Steam Packet Company Limited.

Below: *Graceful* (1911/1,149 grt.) F. H. Powell & Company Limited.

Above: *Victoria Pier,* Douglas, Isle of Man.

Left: Departure of the London boat at Yarmouth.

Above: Folkestone from the New Pier, 1906.

Below: Arrival of the turbine steamer *King Edward* at Inveraray.

MOTOR VESSEL, "ULSTER PRINCE," 3,800 TONS.
LIVERPOOL-BELFAST EXPRESS SERVICE
ULSTER IMPERIAL LINE (BELFAST STEAMSHIP CO LTD.)

Above: *Ulster Prince* (1930/3,791 grt.) Belfast Steamship Company Limited.

Below: *Hibernia* (1949/4,972 grt.) and *Cambria* (1949/4,972 grt.) at Holyhead.

Right: Launch of *Mona's Queen* on 12 April 1934 at Cammell Laird & Company Limited, Birkenhead.

Below: Sea routes across the English Channel in 1936.

Above: *Prince Baudouin* (1934/3,050 grt.). Belgian Marine Administration.

Below: *Brading* (1948/988 grt.) at Portsmouth.

The "Clacton Belle."

Above: Clacton Belle, 1890, 458 grt. 75 × 8 m.
Built by (b.) William Denny & Brothers Limited, Dumbarton. Yard No. 434.
London, Woolwich and Clacton on Sea Steamboat Company.
She was launched on 26 February 1890 and delivered in May, that year. Broken up at Grays in 1929 by T. W. Ward & Company Limited.

Below: Coningbeg, 1904, 1,429 grt. 82.5 × 11 m.
b. Ailsa Shipbuilding Company Limited, Troon. Yard No. 116.
Clyde Shipping Company Limited.
She was built as *Clodagh* for the Waterford Steamship Company, became *Coningbeg* in 1912. On a voyage from Liverpool to Waterford, on 18 December 1917, she was attacked and sunk by the German submarine U-61, south-west of Bardsey Islands.

Above: Scotia, 1921, 3,441 grt. 116 × 13.8 m. 24 knots.
b. William Denny & Brothers Limited, Dumbarton. Yard No. 1037.
London, Midland & Scottish Railway.
She was ordered in 1914 and launched on 16 November 1920. On her trials on 14 December 1921, she attained a speed of 24.86 knots which made her the fastest vessel built at the yard. She was transferred to the London, Midland & Scottish Railway on 1 January 1923 and underwent a major refit in April 1923. On 1 June 1940, she was sunk by German air bombing at Dunkirk. She had taken around 2,000 troops from the beaches when a bomb destroyed her engine room. Thirty-two of her crew and approximately 300 soldiers lost their lives.

Below: Empress Queen, 1897, 2,140 grt. 113.39 × 13.11 m. 21 ½ knots.
b. Fairfield Shipbuilding & Engineering Company Limited, Govan. Yard No. 392.
Isle of Man Steam Packet Company Limited.
She was launched on 4 March 1897 and was requisitioned by the Admiralty in 1915. On 1 February 1916, she was stranded on Bembridge Ledge, Isle of Wight and became a total loss.

Fred Olsen *Black Prince* advertisement 1938.

Vega and *Venus* advertisement 1938.

Above: *Duchess of Fife*, 1903, 336 grt. 64.1 × 7.6 m.
b. Fairfield Shipbuilding & Engineering Company Limited, Govan. Yard No. 432.
Caledonian Steam Packet Company Limited.
She was launched on 9 May 1903, requisitioned by the Admiralty in 1916 and renamed *Duchess*. She became *Duchess of Fife* in 1919 and was transferred to the London, Midland & Scottish Railway in 1923.

In 1939, she was owned by the Caledonian Steam Packet Company Limited. She arrived at Port Glasgow on 15 September 1953 and was broken up by Smith & Houston Limited.

Below: *William Cooper*, 1925, 772 grt. 55.1 × 9.8 m.
b. Gironde, Harfleur, France. Yard No. 18.
William Cooper & Company Limited.
She was built as *Foremost 38* in 1925 and converted to a grab dredger in 1941. She became a store-ship in 1952, reverted to hopper and renamed *William Cooper* in 1963. In 1964, she was renamed *P. M. Cooper* and was broken up at Dalmuir by W. H. Arnott Young & Company Limited in 1968.

Above: *Coronia*, 1935, 227 grt. 39.5 × 8 m.
b. Warrens Limited, New Holland. Yard No. 267.
J. S. Ellis & Company Limited.
She was launched on 4 May 1935 and renamed *Bournemouth Queen* in 1968, *Queen of Scots* in 1975 and *Rochester Queen* in 1983.

Below: Mailbags loaded onto the British Rail cross-Channel Dover–Calais packet *Canterbury* at Dover.

Left: *Conister*, 1921, 411 grt.
Conister and *Fenella* loading cargo at Coburg Dock, Liverpool.
Conister was built as *Abington* for G. T. Gillie & Blair of Newcastle and was acquired by the Isle of Man Steam Packet Company on 8 January 1932. She gave many years of service with the company and left Douglas under tow of the tug *Campaigner* on 26 January 1965 for Dalmuir, where she was broken up. *Fenella* was built for the Steam Packet by the Ailsa Shipbuilding Company on the Clyde in 1951. She was sold to Cypriot Juliet Shipping Company and sailed from Birkenhead on 9 February 1973 as *Vasso M*. In May 1978, she caught fire and sank in the Mediterranean.

Below: Barges loaded with grain in the Liverpool Dock system.

Above: *Authenticity*, 1942, 861 grt. 57.30 × 9.44 m. 10 knots.
b. Goole Shipbuilding & Engineering Company Limited, Goole. Yard No. 371.
F. T. Everard & Sons Limited.
She was built as *Empire Harp* and was renamed *Anis* in 1948 and *Authenticity* in 1954. She was lengthened (67.5 m. 983 grt.) in 1956, became *Petrola I* in 1966 and was broken up in 1984.

Below: *Crosby Dale*, 1927, 213 grt. 31.08 × 6.91 m. 8 knots.
b. Cammell Laird & Company Limited. Yard No. 927.
T. Routledge & Company Limited.
She was launched as *Xanthus* for the Blue Funnel Line on 17 May 1927 and was sold to T. Routledge & Company Limited in 1959 and renamed. In June 1968, she was towed to Dalmuir by the Alexandra tug *Egerton* and broken up by W. H. Arnott Young & Company.

Above: *Medina*, 1931, 342 grt. 43.6 × 8.6 m. 11 knots.
b. Thornycroft Limited. Yard No. 1105.
Southampton, Isle of Wight & South of England Royal Mail Steam Packet Company Limited. She was delivered as the first diesel vessel on Isle of Wight service in 1931 and sold and renamed *Mons Abyla* in 1962. She became *Marilu* in 1972 and was hulked as *Medina* in 1973. She was renamed *Island Pride* in 1975 and broken up at South Shields by C. O'Brien & Sons Limited in 1997.

Below: *Robert the Bruce*, 1934, 228 grt. 45.4 × 14 m. 9 knots.
b. William Denny & Brothers Limited. Yard No. 1267.
Operated by William Denny & Brothers Limited.
Denny Forth Ferry.
She was launched on 29 January 1934 and introduced into service with her sister *Queen Margaret*. The vessels carried 28 cars each and operated on the route between South Queensway and North Queensway until the Forth Road Bridge opened in 1964. Both ships were broken up the following year.

Above: *Medway Queen*, 1924, 318 grt. 54.8 × 7.4 m.
b. Ailsa Shipbuilding Company Limited, Troon. Yard No. 388.
New Medway Steam Packet Company Limited.
She was launched on 23 April 1924, converted to a floating restaurant in 1964 and underwent restoration in 2013.

Below: *Arlingham*, 1934, 268 grt.
b. Van Diepen, Waterhuizen. Yard No. 810.
She was delivered as *Charlotte Bohl*, became *Mr Harm Smeenge* in 1934, *Frejo* in 1946, *Atlantis* in 1951, *Tramp* and *Zeearend* in 1956, *Isle of Harris* in 1958 and *Arlingham* in 1965.

Above: ICI barges transferring cargo to a Port Line cargo vessel in Liverpool's northern dock system.

Below: Esso Brixham, 1957, 828 grt. 64.92 × 9.75 m. 10 knots.
b. Philip & Son Limited, Dartmouth. Yard No. 1291.
Esso Petroleum Company Limited.
She arrived at Middlesbrough in May 1980 and was broken up by BDK Engineering Company.

Above: *Jacinth*, 1937, 650 grt. 54.3 × 8.7 m. 10 knots
b. Henry Robb & Company Limited, Leith. Yard No. 246.
Gem Line Limited (William Robertson Limited).
She arrived at Dalmuir on 30 March 1970 and was broken up.

Below: *Blackthorn*, 1960, 749 grt. 57.8 × 10.3 m. 10 knots.
b. Westerbroek S. W. Limited. Yard No. 157.
S. W. Coe & Company Limited (Thorn Line).
She was launched on 30 December 1959, was converted to an aggregates carrier and renamed *Rudyard* in 1976. She became *Jane Sea* in 1980 and was scuttled as a diving reef (12.29N/69.59W) in January 1988.

Above: Bowline, 1953, 596 grt. 54.6 × 8.9 m.
b. Bodewes, G&H, Martenshoek. Yard No. 399.
F. Bowles & Sons Limited.
She was broken up at Cardiff in 1976.

Below: Valzell, 1935, 553 grt. 51.2 × 9.2 m. 9 ½ knots.
b. Caledon Ship Building & Engineering Company Limited. Yard No. 347.
J. Tyrrell Limited, Arklow.
She was launched as *Arbroath* on 14 August 1935 and was purchased and renamed *Valzell* in 1962. She arrived at Passage West in November 1972 and was broken up by Haulbowline Industries Limited.

Above: *Ben Ain*, 1966, 500 grt. 55.9 × 8.7 m. 8 knots.
b. Boeles's Limited, Boeles. Yard No. 1023.
Ramsey Steamship Company Limited.
On 18 February 1966, she was launched as *Deben*, became *Gretchen Weston* in 1971, *Ben Ain* in 1976 and *Prince, Abdoulah, Abdoulah 1* in 1991. She was lost on 8 September 2001.

Below: *Indorita*, 1920, 201 grt.
b. Abdela & Mitchell Limited, Queensferry. Yard No. 408.
Coppack Brothers & Company Limited.
She was launched in February 1920 and arrived at Gijon on 26 March 1974 and was broken up.

Left: *Cabourne*, 1931, 525 grt. 48.6 × 7.8 m.
b. De Noord, Alblasserdam. Yard No. 495.
Coastal Carriers Limited, Grimsby.
She was delivered as *Ngatira* in October 1931, became *Springwood* in 1946, *Cabourne* in 1947 and *Delfino* in 1968. She was broken up at Massawa in 2000.

Below: *Dundalk*, 1938, 699 grt.
56.69 × 10.66 m.
b. Ardrossan Dockyard Limited, Ardrossan.
Yard No. 372.
British & Irish Steam Packet Company Limited.
She was launched on 10 November 1938, purchased by Varverakis & Company, Greece in 1966 and renamed *Alexis*.
 On 5 September 1966, on a voyage from Constantza to Beirut with a cargo of sheep and eggs, she sank 35 miles west of Paphos, Cyprus.

Above: *Kingston*, 1956, 1,873 grt. 83.9 × 12 m.
b. Burntisland Ship Building Company Limited, Burntisland. Yard No. 367.
South Eastern Gas Board.
She was launched on 19 October 1956 and delivered on 12 December. She was renamed *Tsimention* in 1971, arrived at Eleusis on 20 September 1983 and broken up by Vionav Limited.

Below: Cars and vans being loaded onto the Belfast Steamship Company vessel *Ulster Prince* (1937/4,303 grt.) at Liverpool Landing Stage for a rare summer Sunday daylight sailing.

Above: *Scillonian*, 1956, 921 grt. 64 × 10.1 m. 15 knots.
Thornycroft & Company Limited, Woolston. Yard No. 4130.
Isles of Scilly Steamship Company Limited.
She was launched on 15 November 1955 and became *Devonia* in 1977, *Devoniun* in 1982, *Syllingar* in 1984, *Remvi, African Queen, Princess Eliana* in 1986 and *Olga I* in 1998.
26 June 2007: Haulked.

Below: *Wakefield*, 1958, 1,113 grt. 74.46 × 11.97 m. 12 ½ knots.
b. A&J Inglis Limited, Pointhouse. Yard No. 1623.
Associated Humber Lines Limited.
She was launched on 19 May 1958, transferred to the Hull–Antwerp service on 3 February 1968, sold to Medship Limited, Cyprus (Gulf Maritime Company as managers) in 1972 and became *Gulf Coast*. In 1974, she was sold to Taj Shipping Company, Cyprus, with the same managers. On a voyage from Ipswich to Tema in 1976, she grounded 50 miles from Sinu. She berthed at Sinu, but caught fire and beached following an explosion. She was declared a total loss.

Above: Ben My Chree, 1927, 2,586 grt. 111.56 × 14.02 m. 22 ½ knots.
b. Cammell Laird & Company Limited, Birkenhead. Yard No. 926.
Isle of Man Steam Packet Company Limited.
She was launched on 5 April 1927 and sailed on her maiden voyage on 29 June. Her final voyage Douglas–Liverpool took place on 13 September 1965. She left Birkenhead under tow of tug *Fairplay XI* on 18 December 1965 and was broken up at Ghent.

Below: Lady of Mann, 1930, 3,104 grt. 113.08 × 15.30 m. 22 ½ knots.
b. Vickers Armstrong Limited, Barrow.
Isle of Man Steam Packet Company Limited.
She was launched on 4 March 1930 and sailed on her maiden voyage on 28 June. Her final voyage took place on 17 August 1971, and she left Barrow under tow of tug *Wrestler* on 29 December 1971 and was broken up by W. H. Arnott Young at Dalmuir.

Ben My Chree (4), 1927, 2,586 grt.

Ben My Chree (5), 1966, 2,762 grt.
104.83 × 16.13 m. 21 ½ knots.
b. Cammell Laird & Company Limited. Yard No. 1320.
Isle of Man Steam Packet Company Limited.
She was launched on 10 December 1965 and sailed on her maiden voyage Liverpool–Douglas on 12 May 1966. Her final voyage operated on 19 September 1984, and she was sold to New England Development Company, Cincinnati the following year to be converted to a restaurant ship at Jackson, Florida, USA.

Chartered to the IOMSPC between 25 May 1985 and 10 June 1985. She was resold to shipbreakers at Santander, Spain in 1989, left Birkenhead in tow of the Rea tug *Hollygarth* on 16 August 1989 and was broken up at Santander.

Above: *Holyhead Ferry 1*, 3,879 grt. 112.47 × 17.43 m. 21 knots.
b. Hawthorn Leslie Limited, Newcastle. Yard No. 757.
British Railways Board.
She entered service on the Holyhead–Dun Laoghaire route in 1965. She operated on the Weymouth–Channel Islands service in place of the damaged *Caesarea* on 2 March 1973 and was converted to operate on the English Channel by Swan Hunter on the Tyne in 1976. She replaced *Artevelde* at Dover on 23 September 1976 and took 20 hours to complete a Boulogne–Dover sailing in severe gale conditions on 14 October 1976. She was at sea for 10 hours in a gale in the Irish Sea on 28 January 1978. On a voyage from Calais to Folkestone on 26 February 1979, she collided with the pier and was out of service for two weeks.

On 27 October 1980, she was replaced by *St Anselm*, laid up at Newhaven and briefly stood in for *Earl Siward*. She was sold on 30 May 1981 and was broken up in Spain.

Below: *Arklow*, 1948, 312 grt. 41.6 × 7.4 × 2.55 m.
b. N. V. Scheepswerf 'Voorwaarts' v/h E. J. Hylkema in Martenshoek. Yard No. 153.
Arklow Shipping Company Limited.
She was built as *Banka*, became *Arctic* in 1955, *Herta II* in 1958, *Eisbar* in 1963, *Arklow* in 1970 and was converted to a dredger in 1973 as *KB*. She arrived at Rainham on 5 January 1989 and was broken up.

Above: Duke of Lancaster.

Below: Firth Fisher, 1950, 974 grt. 66.9 × 9.9 m. 10 knots.
b. Goole Shipbuilding Company Limited, Goole. Yard No. 472.
James Fisher & Son Limited.
She was launched as *Turkis* on 24 October 1949 and purchased and renamed *Firth Fisher* in 1954. She was sold and renamed *Agioi Anargyroi III* in 1971 and was broken up in Greece in 1986.

Above: *Aberthaw Fisher*, 1966, 2,355 grt. 86.6 × 16.5 m. 11 ¾ knots.
b. Ailsa Shipbuilding Company Limited, Troon. Yard No. 522.
James Fisher & Son Limited.
She was launched on 18 February 1966 and renamed *National Generation* in 1990.
She became *Aberthaw Fisher* in 1992, was converted to a mining dredger (2,609 grt./2,233dwt.) in 1996 and renamed *Moonstar*. She arrived at Alang on 14 October 2000 and was broken up.

Below: *Glen Sannox*, 1957, 1,107 grt. 78.5 × 14.1 m. 17 knots.
b. Ailsa Shipbuilding Company Limited, Troon. Yard No. 496.
Caledonian Steam Packet Company Limited.
She was launched on 30 April 1957, sold and renamed *Knooz* and *Nadia* in 1989, *Al Marwah* in 1991, *Al Basmalah 1* in 1994 and was lost in 2000.

31

Above: *Maid of Cumbrae*, 1953, 508 grt. 49.16 × 8.53 m. 13 knots.
b. Ardrossan Dockyard Limited, Ardrossan. Yard No. 419.
Caledonian Steam Packet Company Limited.
She was launched on 13 May 1953 and sailed on her maiden voyage Glasgow–Dunoon on 18 July 1953. She was transferred to the Scottish Transport Group on 1 January 1969, and in 1972, side ramps were fitted for the Gourock–Dunoon vehicle service, entering service operating with Glen Sannox on 27 May. On 1 January 1973, she was owned by the Caledonian Steam Packet Company Limited and was converted to an aft-loading car ferry. She was laid up in James Watt Dock, Greenock in October, 1976 and two years later was sold and renamed *Hanseatic*. She was then resold to Nav Alto Tirreno and renamed *Noce di Cocco*.

In 1984, she operated on the Naples–Capri route as *Capri Express* and arrived at Aliaga on 13 March 2006 and was broken up.

Below: *Claymore*, 1955, 1,024 grt. 58.61 × 10.67 m. 12 ½ knots.
b. William Denny & Brothers Limited, Dumbarton. Yard No. 1482.
David MacBrayne Limited.
She was launched on 10 March 1955 and delivered on 16 June to replace *Lochearn* on the Inner Isles routes. In 1965, she was employed on summer cruises out of Fort William, and in 1972, replaced by *Loch Seaforth* on the Oban–Lochboisdale service. She was sold in 1976 to Canopus Shipping S. A. and was renamed *City of Andros*, owned by Andreas and George Kyrtatas, Piraeus with Canopus Shipping as managers. She was later renamed *City of Hydra*, laid up on 1 February 1993 and foundered in Eleusis Bay on 24 November 2000.

Above: *Claymore*, 1978, 1,631 grt. 77.20 × 16.26 m. 17 knots.
b. Robb Caledon Shipbuilders Limited, Leith. Yard No. 522.
Caledonian MacBrayne Limited.

Below: As *Sia* in the River Mersey, following a visit to Cammell Laird's shipyard at Birkenhead.

Above: *Lochmor*, 1979, 189 grt. 30.92 × 7.98 m. 11 knots.
b. Ailsa Ship Building Company Limited, Troon. Yard No. 554.
Caledonian MacBrayne Limited.
She was launched on 11 June 1979 for Oban and inner Isles services and introduced summer services to Kyle, Crowlin Islands in 1981. She was employed at Oban, on Mallaig–Egg–Muck–Rum–Canna services, in 1993 and was renamed *Loch Ewe* in 2001. In 2003, she was sold and renamed *Torbay Belle* and *Jurassic Scene* in 2010.

Below: *Countess of Breadalbane*, 1936, 106 grt. 27.71 × 5.52 m. 10 knots.
b. William Denny & Brothers Limited, Dumbarton. Yard No. 1294.
Williamson-Buchanan Steamers Limited.

Above: *Caledonian Princess* postcard.

Below: *Caledonian Princess*, 1961, 3,630 grt. 107.59 × 16.76 m. 20 ½ knots.
b. William Denny & Brothers Limited, Dumbarton. Yard No. 1501.
Caledonian Steam Packet Company (Irish Services) Limited.

35

Above: *Adriatic Coast*, 1949, 1,050 grt. 75.2 × 12.1 m. 12 knots.
b. Hall Russel & Company Limited, Aberdeen. Yard No. 811.
Coast Lines Limited.
She was launched on 1 March 1949 and sold to Greek interests on 3 October 1968 and renamed *Trader*. She became *Ermis* in 1972, *Potamia* in 1973 and *Stella III* in 1975. She was broken up in 1980.

Below: *Ballyhill* **follows** *Lion* **up the River Lagan.**
Ballyhill, 1954, 847 grt. 60 × 9.7 m. 10 knots.
b. George Brown & Company Limited, Greenock. Yard No. 257.
John Kelly Limited.
She was launched on 19 December 1953 and lengthened (70.1 m/986 grt.) in 1963. She was sold on 26 December 1973 and demolition work commenced at Gijon. The work was completed on 27 April the following year.

Above: *Norwest Laird*, 1939, 603 grt. 57.91 × 9.78 m. 12 knots.
b. William Denny & Brothers Limited, Dumbarton. Yard No.
Courage (Western) Limited, Bristol.
She was launched on 4 April 1939 for David MacBrayne Limited for the West Loch Tarbert–Islay–Gigha–Jura–Colonsay and Oban–Fort William services to replace *Pioneer*. Following new regulations, a main mast was fitted in 1953. On 8 October 1960, she ran aground on rocks at West Loch Tarbert and was out of service for six months. She was withdrawn during 1969–70 and sold to Norwest Shipping Limited, becoming *Norwest Laird* for a service from Fleetwood to Douglas, Isle of Man. However, she only completed 14 trips and was laid up at Glasson Dock. In 1972, she was owned by Leigh & Sullivan Limited, Macclesfield and was sold to Frederick Oldham Limited, Liverpool in 1973. On 2 February 1974, she was towed to Barrow for inspection and survey, and in March 1974 was laid up at Hayle, Cornwall and sold to Courage (Western) Limited, Bristol for use as a floating restaurant. In November 1975, her engines were removed, and she was moored at City Dock, Bristol as a restaurant in 1978. She was broken up at Bristol by M. C. Stuckey in November 1995.

Below: *Stella Marina*, 1965, 1,884 grt. 77.6 × 12 m.
b. Rolandwerft, Bremen. Yard No. 925.
Norwest Hovercraft Limited.
She became *Holiday Princess* in 1970, *Marianna* in 1971, *Chrysanthemum* in 1975, *Expresso Brindisi* in 1980 and *Casamance Express* in 1982. She was scuttled in 1996.

Above: *Leinster* (1947/4,088 grt.), *Munster* (1947/4,088 grt.) and *Scottish Coast* (1957/3,817 grt.) in Princes Dock, Liverpool.

Below: *Hibernia* at Dun Laoghaire.

Above: Coast Lines' and British Rail's vessels berthed at Belfast.

Below: *Spaniel* at Ardrossan.
Spaniel, 1955, 891 grt. 68.28 × 11.58 m. 11 knots.
b. George Brown & Company Limited, Greenock. Yard No. 262.
Coast Lines Limited.
She was launched as *Brentfield* on 21 June 1955 and renamed *Spaniel* in 1959. She was transferred to Burns & Laird Line in 1965, was sold to the Isle of Man Steam Packet Company Limited in November 1973 and was sold becoming *Conister*. She arrived at Aviles on 29 September 1981 and was broken up.

Above: Helmsley 1 (1916/1,179 grt.)
Helmsley 1 was a coastal tanker and is shown at Liverpool Landing Stage transferring fuel to the Canadian Pacific liner *Empress of Canada*. She was sold to Belgian interests in 1969 and sailed from Liverpool to Antwerp, where she was due to be broken up. However, she foundered on rocks at Fox Cove, between Porthcothan Bay and Treyarnon Bay on 12 May 1969. Her master sent out a Mayday call and reported that she was aground under the Lizard Light, but was actually near the Trevose Head Light. Coastguard and lifeboats were sent to search in the wrong location, but the crew managed to scramble ashore safely. Three crewmen were treated at the Royal Cornwall Hospital, Truro for minor injuries and the vessel later broke up on the beach where she lay.

Below: Suilvan at Picton, New Zealand.
Suilven, 1974, 1,908 grt. 86.52 × 16.03 m. 15 ¾ knots.
b. Moss Rosenberg Vaerft A/S, Moss. Yard No. 180.
Caledonian MacBrayne Limited.
She was purchased on the stocks to replace *Clansman* in 1974 and was launched for the Ullapool–Stornoway route on 19 April 1974. In 1976, she was transferred to Caledonian MacBrayne Holdings Limited and sold to Strait Shipping Limited, New Zealand in 1995. In 2004, she was owned by Bligh Water Shipping, Fiji and was sold to Vanu Shipping Limited, Fiji in 2015. On 24 November 2015, she capsized and sank in Suva Harbour and was declared a total loss.

Above: *Caledonia*, 1966, 1,156 grt. 61.81 × 12.19 m. 19 knots.
b. A/S Langesunds Mek Verkstad, Langesund. Yard No.
Caledonian Steam Packet Company Limited.
Delivered as *Stena Baltica* to Stena A/B., Gothenburg in 1966.
She was purchased by the Caledonian Steam Packet (Scottish Transport Group) and arrived at James Watt Dock, Greenock on 11 January 1970, where she was refitted at a cost of £100,000, prior to entering service on the Ardrossan–Brodick route. In 1977, she suffered two engine breakdowns, was sold to Libertà Nav. Lauro S. a. S., Italy in 1990 and renamed *Heidi*. She arrived at Aliaga on 20 April 2006 and was broken up.

Below: *Halladale*, 1944, 1,370 grt. 91.8 × 11.1 m.
b. A&J Inglis Limited, Pointhouse. Yard No. 1226.
Townsend Brothers Ferries Limited.
In 1950, Halladale was converted into a car ferry (1,370 grt.) to operate from Dover to Calais. In 1962, she became *Norden*, *Turist Expressen* and *Ferrymar III*. In 1971, she was sold and broken up at Curaçao.

Brighton, 1950, 2,875 grt. 95 × 13.2 m. 24 knots.
b. William Denny & Brothers Limited, Dumbarton. Yard No. 1428.
British Transport Commission – Southern Region.

Lisieux, 1953, 2,943 grt. 95.5 × 13 m. 25 knots.
b. Méditerranée, Le Havre.
S. N. C. F., managed by the Southern Region.
Lisieux was launched on 26 February 1952 for English Channel services. She was sold in 1966, became *Apollon* and was broken up by K. Kyriakou & Company at Eleusis, where she arrived on 12 October 1982.

Above: Dover Harbour in the 1960s.

Below: Invicta, 1939, 4,178 grt. 117.19 × 15.27 m. 22 knots.
b. William Denny & Brothers Limited, Dumbarton. Yard No. 1344. Southern Railway.

Above: *Falaise*, 1946, 3,710 grt. 94.64 × 15.1 m. 20 ½ knots.
b. William Denny & Brothers Limited, Dumbarton. Yard No. 1400.
Southern Railway.

Below: *Maid of Orleans*, 1949, 3,776 grt. 103.94 × 15.24 m. 22 knots.
b. William Denny & Brothers Limited, Dumbarton. Yard No. 1414.
British Transport Commission.

Above: *Twickenham Ferry*, 1934, 2,839 grt. 105.7 × 18.5 m. 16 ½ knots.
b. Swan, Hunter & Wigham Richardson Limited, Newcastle. Yard No. 1446.
Southern Railway.

Below: *Valencay*, 1965, 3,430 grt. 105 × 17.1 m.
b. Atlantique (Penhoet-Loire), St Nazaire, France. Yard No. E23.
Soc Nationale des Chemins de Fer Français.
She was launched on 6 February 1965 to be employed on cross-Channel services from France to England. She was sold in 1984, became *Eptanisos*, *Pollux* in 2000 and *Pollux 1* in 2003. She was broken up at Gadani Beach in 2004.

45

Above: Chantilly, 1966, 3,400 grt. 109.9 × 17.8 m.
b. Dubigeon-Normandie, Nantes-Chantenay. Yard No. 822.
Soc Nationale des Chemins de Fer Français.
She was launched on 9 November 1965, for cross-Channel services from France to England. In 1987, she was sold and renamed *Olympia*, *Europa Link* in 1990, *Baltavia* in 1993 and *Al Salam 93* in 1996. She was broken up in 2003.

Below: Maid of Kent, 1959, 4,413 grt. 113.7 × 18.4 m. 20 knots.
b. William Denny & Brothers Limited, Dumbarton. Yard No. 1492.
British Transport Commission.

Above: *Free Enterprise 1*, 1962, 2,607 grt. 96.5 × 16.4 m.
b. N. V. Werft Gusto, Schiedam, Holland. Yard No. 424.
Townsend Brothers, Ferries Limited.
She was launched as *Free Enterprise* on 2 February 1962, becoming *Free Enterprise 1* in 1964. In 1980, she was sold and became *Kimolos*, *Ergina* in 1993, *Ventouris* in 1994, *Methodia II* in 1995, *Kallisti* in 1996, *Okeanis* in 2005 and *Oceanis* in 2013. She arrived at Aliaga on 3 June 2013 and was broken up.

Below: *The Princess Margaret* (1968/280 grt.) was built by the British Hovercraft Corporation Limited at East Cowes and was operated from Dover to Boulogne by Hoverspeed Limited. The company ceased operating in 2000, and the *Princess Margaret* and *Princess Anne* went to the Hovercraft Museum at Lee-on-the-Solent.

Above: *Free Enterprise III*, 1966, 4,657 grt. 117.51 × 19.08 m. 20 knots.
b. N. V. Werft Gusto, Schiedam, Holland. Yard No. 324/c0538.
Townsend Brothers, Ferries Limited.
She was launched on 14 May 1966 for the service from Dover to Calais. In July 1984, she was sold to Mira Shipping, renamed *Tamira*, acquired by the Isle of Man Steam Packet on 26 October that year and became *Mona's Isle*. She sailed on her maiden voyage on 5 April 1985 and took her final sailing on 5 October 1985. She was sold to Saudi Arabian interests, renamed *Al Fahad* and sailed from Birkenhead on 7 April 1986. In April 1996, she was laid up and was semi-submerged by June 2004, 35 km south of Jeddah.

Below: *Reine Astrid*, 1958, 3,795 grt. 114 × 15.2 m. 23 knots.
b. Cockerill-Ougree, Hoboken. Yard No. 785.
Belgium Marine Administration.
She was launched on 25 July 1957 for cross-Channel services from Ostend to Dover. In 1985, she was hulked at Flushing.

Above: *Artevelde*, 1959, 2,812 grt. 116.9 × 16 m. 21 knots.
b. Cockerill-Ougree, Hoboken. Yard No. 794.
Belgium Marine Administration.
She was launched on 1 February 1958, for cross-Channel services from Belgium to England. She was sold in 1976, became *Aegeon* and suffered a serious fire at Drapetzona on 19 February 1996. She was beached and capsized at Atalanti Island.

Below: *St Patrick*, 1948, 3,482 grt. 97.9 × 14.69 m. 20 knots.
b. Cammell Laird & Company Limited, Birkenhead.

Above: Norris Castle, 1968, 734 grt. 58.3 × 12.8 m.
b. Vosper Thornycroft Limited, Woolston. Yard No. 4226.
Southampton, Isle of Wight & South of England Royal Mail Steam Packet Company Limited.
She was delivered in 1968 for services to the Isle of Wight and was lengthened in 1976 (67.4 m/922 grt.). In 1994, she was sold, renamed *Lovrjenac* and was broken up at Aliaga, where she arrived on 5 July 2011.

Below: Munster, 1968, 4,067 grt. 110.2 × 18.1 m.
b. Nobiskrug, Rendsburg. Yard No. 657.
British & Irish Steam Packet Company Limited.
She was introduced in 1968 on the Liverpool–Dublin service as the route's first roll on/roll off car ferry. In 1983, she was sold and became *Farah* and *Farah 1* and *Tian Peng* in 1990. She was broken up in China in 2002.

Above: *Saint Colum I,* 1973, 5,285 grt. 118 × 18.2 m.
b. Schichau Unterweser, Bremerhaven. Yard No. 485.
Belfast Car Ferries Limited.
She was launched as *Saint Patrick* on 17 January 1973 and became *Saint Colum 1* in 1982. She was sold in 1990, renamed *Dimitrios Express* and *Poseidon Express 2* in 1996, *Express Poseidon* in 2000, and *Express P* in 2005. She arrived at Alang on 6 August 2005 and was broken up.

Below: *St Trillo*, 1936, 314 grt. 48 × 8 m. 13 ½ knots.
b. Fairfield Shipbuilding & Engineering Company Limited.
Liverpool & North Wales Steamship Company Limited.
She was delivered as *St Silio*, became *St Trillo* in 1945 operating cruises from Llandudno, North Wales and Menai Bridge, Anglesey until the company went into voluntary liquidation in 1962. She was sold to P&A Campbell in 1963 and was converted into a floating restaurant in 1972. She was broken up at Dublin in 1975.

Above: *Queen of the Isles*, 1965, 515 grt. 48 × 9 m. 13 knots.
b. Charles Hill & Sons Limited, Bristol.
Isles of Scilly Steamship Company Limited.

Below: *Gosport Queen* (1966/159 grt.) at Portsmouth. She was built by Thornycroft Limited at Woolston, for the crossing between Gosport and Portsmouth.

Above: Devonium, 1964, 2,104 grt. 71.00 × 14.11 m. 14 ½ knots.
b. Hall, Russell & Company Limited, Aberdeen. Yard No. 910
Torbay Seaways & Stevedores Limited.
She was built as *Hebrides* and entered service on 8 April 1964 on the Uig (Skye)–Lochmaddy (North Uist)–Tarbert (Lewis) route, relieving *Lochmor*, which was transferred to Mallaig. She was sold to John and Maureen Thompson of Torbay Seaways and Stevedores Limited, Torquay in 1986. The company was taken over by Jersey interests, and she was purchased by Aubreyville Limited in 1991. Two years later, she became *Illyria* and arrived at Aliaga on 31 July 2003 and was broken up by Huzur GS.

Below: Caesarea, 1960, 4,174 grt. 98.14 × 16.37 m. 19 ½ knots.
b. Samuel White & Company Limited, Cowes. Yard No. 2008.
Southern Region.
She sailed on her maiden voyage from Weymouth to the Channel Islands on 2 December 1960 and was relieved on the 'Golden Arrow' service in December–January 1966. On 11 March 1973, she was damaged by grounding at Jersey and operated her final Channel Islands sailing on 6 October 1975, prior to being transferred to Dover. In 1977, she was operating on the Folkestone–Boulogne route and was transferred to Sealink UK Limited on 1 January 1979. *Caesarea* was sold to Superluck Enterprises Incorporated in 1980 and became *Aesarea* on arrival at Hong Kong's Shamshupo anchorage. On 9 September 1983, she was driven ashore during storm 'Ellen', but was refloated the following day. She was broken up in 1985.

Above: Viking II, 1964, 3,670 grt. 99.5 × 17.7 m.
b. Kaldnes M. V., Tonsberg. Yard No. 160.
Otto Thoresen Shipping Company.
She was launched on 28 May 1964 for a new service from Southampton to Cherbourg and Le Havre. She was renamed *Carferry Viking II* in 1964, *Earl William* in 1977, *William* and *Pearl William* in 1992, *Mar Julia* in 1996, *Cesme Stern* in 1997 and *Windward II* on 2001. She was lost on 2 April 2011.

Below: Lord Warden, 1952, 3,333 grt. 110.37 × 18.5 m. 20 knots.
b. William Denny & Brothers Limited, Dumbarton. Yard No. 1455.
British Transport Commission – Southern Region.

Above: *St Edmund*, 1974, 8,987 grt. 130.41 × 22.65 m. 21 knots.
b. Cammell Laird & Company Limited, Birkenhead. Yard No. 1361.
British Railways Board.
She was named on 13 November 1973, but her launch was delayed for 24 hours because of gales. She was delivered to British Railways Board for the Harwich–Hook of Holland service, replacing *Avalon*. In January 1975, she was sold to Passtruck (Shipping) Company Limited, and chartered back to British Railways. On 12 May 1982, she left Harwich on charter to the Ministry of Defence to be used as a troopship in the Falklands conflict. She was sold for use as a troopship between Ascension Islands and the Falklands in 1983, while the airport was under construction at Port Stanley, and renamed *Karen*. On 4 July 1985, she arrived back in the United Kingdom and was laid up in the River Stour. Acquired by Cenargo Limited in 1985, she became *Scirocco* and renamed *Rozel* for the Poole–Channel Islands service in 1989. She became *Scirocco* again in 1993, *Santa Catherine 1* in 2004 and *Sara 3* in 2006. She was broken up in India in 2009.

Below: *Anderida*, 1972, 1,601 grt. 106 × 16.08 m. 17 knots.
b. Trosvik Verksted A/S., Kristiansund. Yard No. 95.
Sealink Limited.
She was built for Carpass (Shipping) Company, London on charter to British Railways' Southern Region replacing *Shepperton Ferry*. On 1 May 1976, she was operating out of Holyhead, replacing *Preseli* and later returned to Dover. She operated on the Heysham–Belfast route later that month after *Penda* was damaged by fire off Barrow. She also operated from Fishguard, Holyhead and Stranraer that year. On 30 October 1981, she was sold to Covenant Shipping Inc. of Monrovia and became *Truck Trader*. She became *Sealink* when sold to Marlborough Sealink Limited in 1985, *Mirela* in 1986 and *C. T. M. A. Voyageur* the following year.

55

Above: *Norman Commodore*, 1971, 496 grt. 69.2 × 11.1 m.
b. Rolandwerft, Berne. Yard No. 977.
Commodore Transporters Limited.
She was launched on 12 November 1970 and was lengthened in 1977 (79.00 m/589 grt.). She was sold in 1991, became *Celtic Venture*, *Moro II* in 2002 and *Farouk M.* the following year. On a voyage from Alexandria to Lattakia, with a cargo of ceramics, she foundered on 14 December 2008.

Below: *Wilmington*, 1969, 5,689 grt. 125 × 16.7 m.
b. Hall Russell & Company Limited, Aberdeen. Yard No. 942.
Stephenson Clarke Limited.
She was launched on 3 June 1969 and delivered to her owners in September that year. She arrived at Zeebrugge on 17 May 1986 and was broken up by Bruges Scheepssloperij.

Above: *Yewforest*, 1958, 1,097 grt. 67.6 × 10.8 m.
b. J. Lamont & Company Limited, Port Glasgow. Yard No. 392.
John Stewart & Company Shipping Limited.
She was completed in February 1958, was sold in 1974 and became *Mary M.* and *Lockma 1* in 1977. She was abandoned at Suez on 15 November 1986 and was broken up there in April the following year.

Below: *Hamble*, 1964, 1,182 grt. 65.5 × 11.4 m. 10 ½ knots.
b. Henry Robb Limited, Leith. Yard No. 486.
Shell-Mex & B. P. Limited.
She was delivered on 24 April 1964 and lengthened and deepened in 1982 (83.7 m/ 1,658 grt.) She was renamed *Shell Refiner* in 1979, *Metro Star* in 1981, *Erin T.* in 1987 and *Marine Supplier* in 1992. She was deleted from Lloyd's Register on 10 September 2010.

Above: *Consortium 1*, 1972, 2,548 grt. 91 × 14.2 m.
b. Ferguson Brothers Limited, Port Glasgow. Yard No. 463.
North West Water Authority.
She was delivered on 30 May 1972 as a waste disposal vessel for service out of Manchester to the Irish Sea. She was deleted from Lloyd's Register on 6 September 2011.

Below: *Leinster*, 1969, 4,849 grt. 118.3 × 17.8 m.
b. Verolme Dockyard, Cork. Yard No. 9/800.
British & Irish Steam Packet Company Limited.
She was launched on 19 November 1968 for the Dublin–Liverpool car ferry and passenger service. In 1980, she was renamed *Innisfallen*, *Ionian Sun* in 1986, *Chams* in 1993, *Ionian Sun* in 1994 and *Merdif* in 2001. She was broken up at Sachana in 2004.

Above: *Saint Kearan*, 1978, 441 grt. 50.4 × 9.1 m.
b. James W. Cook & Company Limited, Wivenhoe. Yard No. 1457.
J&A Gardner Limited.
She was delivered as a chemical and products coastal tanker in September 1978, sold in 2001 and became *Eide Tank*, *Georgie* in 2001, *Antares* in 2003 and *Markhal* in 2009.

Below: *England*, 1964, 8,221 grt. 140 × 19.3 m. 21 knots.
b. Helsingor Vaerft, Elsinore. Yard No. 369.
Det Forenede Dampskibs-Selskab (DFDS).

Above: Koningen Fabiola, 1962, 4,727 grt. 117 × 15.84 m. 20 knots.
b. J. Boel & Zonen Shipyard, Temse, Belgium.
Belgian Marine Administration.
She was named after the Queen of Belgium and was the first vessel ordered from Boel at Temse. She operated on Belgian Marine's Ostend–Dover passenger and car ferry service. She was sold and broken up in 2004.

Below: Pride of Cherbourg, 1976, 6,387 grt. 128.8 × 20.2 m.
b. Aalborg Vaerft, Aalborg. Yard No. 205.
P&O European Ferries.
She was built as *Viking Voyager* and became *Pride of Cherbourg* in 1989, *Pride of Cherbourg II* in 1994, *Banaderos* in 2000, *Barlovento* in 2000 and *Samothraki* in 2005. She arrived at Aliaga on 22 July 2011 and was broken up.

Above: *Norfolk Ferry*, 1951, 3,157 grt. 121.9 × 18.7 m. 21 knots.
b. John Brown & Company Limited, Clydebank. Yard No. 661.
British Railways Board.
She was delivered in July 1951 for the Harwich–Zeebrugge route and transferred to a new Harwich–Dunkirk service in 1967. On 23 May 1972, she transported new rolling stock for C. I. E., Irish Railways from Holyhead to Dublin (North Wall). The following year, she was transferred to Passtruck (Shipping) Company Limited ownership and to Sealink UK Limited on 1 January 1979. In 1982, she was laid up in the River Blackwater, Essex, coming out to lay up on 14 April 1983 when she was towed to Holland and broken up by Marel B. V. at Vianen.

Below: *King Orry* aground at Glasson Dock in 1976.
King Orry, 1946, 2,485 grt. 105.2 × 14.4 m. 21 knots.
b. Cammell Laird & Company Limited, Birkenhead. Yard No. 1169.
Isle of Man Steam Packet Company Limited.
She was launched on 22 November 1945 and was delivered the following April for the company's Irish Sea routes to the Isle of Man. She sailed on her final voyage on 31 August 1975 and was towed to Glasson Dock from Birkenhead by the tug *Sea Bristolian* on 5 November, that year. On 2 January 1976, she broke adrift from her moorings at Glasson Dock and grounded in the Lune Estuary. She remained there until 14 April when she was successfully floated. *King Orry* was sold and towed to Kent in January 1978, where she was broken up by M. Lynch & Son (Metals) Limited.

Above: *Glenrosa*, 1980, 943 grt. 64.7 × 11.2 m.
b. James W. Cook & Company Limited, Wivenhoe. Yard No. 1463.
Glenlight Shipping Limited.
She was delivered in September 1980 as *Saint Angus* for J&A Garner Limited and renamed *Glenrosa* in 1994, *Union Saint Angus* in 1996 and *Tideway* in 1997. She foundered on 17 May 2006 (13.15N/70.22W).

Below: *Stena Hibernia*, 1977, 7,836 grt. 129.2 × 21.2 m.
b. Aalborg Vaerft, Aalborg. Yard No. 214.
Stena Sealink Limited.
She was launched on 17 July 1976 as *St Columba* for the Holyhead–Dun Laoghaire service. In 1991, she became *Stena Hibernia*, *Stena Adventurer* in 1996, *Express Afroditi* in 1997 and *Masarrah* in 2007.

Above: *Vortigern*, 1969, 4,371 grt. 114.61 × 19.23 m. 19½ k.
b. Swan Hunter Shipbuilding Limited, Wallsend, Newcastle.
British Railways Board.

Below: *European Envoy*, 1979, 6,310 grt. 150 × 21.8 m.
b. Mitsui Engineering & Shipbuilding Company, Tamano, Japan. Yard No. 1163.
P&O European Ferries.
She was launched as *Ibex* on 27 December 1978 and widened to 24.4 m. (18,653 grt./4,267 dwt.) in 1996. She was renamed *Norsea* in 1980, *Norsky* in 1986, *Ibex* in 1995, *European Envoy* in 1997, *Envoy* in 2004, *Envoy 1*, *Reyes B.* and *Envoy1* in 2011. She arrived at Aliaga on 9 January 2012 and was broken up by Oge GS.

Above: *European Navigator*, 1977, 3,809 grt. 144.1 × 18.1 m.
b. Osterreichische Schiffswerten AG, Korneuburg. Yard No. 709.
P&O European Ferries.
She was launched as *Stena Trader* on 15 January 1976 and lengthened by Nobiskrug at Rendsburg. She was renamed *Goya* in 1977, *Federal Nova* in 1979, *Caribbean Sky* on 1981, *Manaure VII* in 1981, *Oyster Bay* and *Viking Trader* in 1983, *Leopard* in 1996, *European Navigator* in 1998, *Black Iris* in 2003 and *Black Horses* in 2012. She arrived at Adabiya, Egypt on 10 January 2014 and was broken up by Oceandro S. Y.

Below: *European Pioneer* (1975/3,453 grt.) and *Superseacat Two*.
European Pioneer was delivered as *Bison* on 24 January 1975, lengthened in 1981 (140.1 m/4,295 grt.) and widened in 1995 (23.8 m/14,387 grt.). In 1997, she became *European Pioneer*, *Stena Pioneer* in 2004 and *Ant 1* in 2011. She arrived at Aliaga on 9 February 2014 and was broken up by Simsekler Gida GS. *Superseacat Two* was built by Fincantieri in 1997 and operated on Irish Sea services to the Isle of Man. She was renamed *Viking* in 2008 and *Hellenic Wind* in 2009.

Above: *Brave Merchant*, 1999, 22,046 grt. 180 × 25.2 m.
b. Ast Españoles (AESA), Seville. Yard No. 288.
Merchant Ferries.
She was launched on 25 May 1998 for the Liverpool–Dublin service. She became *Blanca Del Mar* in 2006, *Ave Liepaja* in 2008, *Norman Bridge* in 2010, *ARV3* in 2012 and *Aquarius Brasil* in 2013.

Below: *Lady of Mann*, 1976, 3,083 grt. 104.43 × 16.74 m. 21 knots.
b. Ailsa Shipbuilding Company Limited, Troon. Yard No. 547.
Isle of Man Steam Packet Company Limited.
She was launched on 4 December 1975. In 1989, she undertook a major refit and conversion at Birkenhead (tonnage increased from 2990 to 3083). She was laid up at Vittoria Dock, Birkenhead on 28 June 1994 following the introduction of *Seacat Isle of Man*. In 2007, she was sold and renamed *Panagia Soumela*. She arrived at Aliaga on 10 August 2011, and was broken up.

Above: *Mona's Queen*, 1973, 2,998 grt. 104.45 × 16.74 m. 21 knots.
b. Ailsa Shipbuilding Company Limited, Troon. Yard No. 547.
Isle of Man Steam Packet Company Limited.
She was launched on 22 December 1972. Her final voyage was on 3 September 1990, and she was laid up at Vittoria Dock, Birkenhead. She was sold to Philippine interests in 1995 and renamed *Mary the Queen*. She arrived at Alang on 1 September 2008 and was broken up.

Below: *Earl William* was built as *Viking II* for Oto Thoresen A/S.

Above: *European Gateway*, 1975, 3,335 grt. 118.3 × 20.3 m.
b. Schichau Unterweser, Bremerhaven. Yard No. 2256.
Townsend Thoresen.
She was lengthened in 1980 (133.5 m/4,263 grt.) as *European Express*. She was renamed *Flavia* in 1983, *Travemunde Link 1* in 1988, *Travemunde Link* in 1989, *Rostock Link* in 1992, *Penelope A* in 1999, *Penelope* in 2005 and *Lopi* in 2013. She arrived at Aliaga on 15 July 2013 and was broken up.

Below: *Isle of Innisfree*, 1995, 22,365 grt. 181.6 × 23.9 m.
b. Van der Giessen de Noord. Yard No. 963.
Irish Ferries Limited.
She was launched on 27 January 1995 for the Holyhead–Dublin service. She became *Pride of Cherbourg* in 2002, *Stena Challenger* and *Challenger* in 2005 and *Kaitaki* in 2007.

Above: *European Mariner*, 1978, 1,598 grt. 116.3 × 18.2 m.
b. Rickmers Limited, Bremerhaven. Yard No. 390.
P&O European Ferries.
She was launched as *Salahala* on 25 October 1977 and became *Merchant Valiant* in 1990, *Lion* in 1995, *European Highlander* in 1998 and *European Mariner* in 2001. She arrived at Aliaga on 25 July 2011 and was broken up by Ege Celik GS.

Below: *River Lune*, 1983, 2,462 grt. 121.5 × 21 m.
b. Galati SN, Galati. Yard No. 765.
Belfast Freight Ferries Limited.
She was delivered as *Balder Vik* and became *Bazias 7* in 1986, *Stena Topper* and *Salar* in 1989, *River Lune* in 1993 and *Hansaland* in 2005.

Above: *Ulster Prince* (1967/4,302 grt.) at Liverpool. Belfast Steamship Company Limited.

Below: *Manx Viking* (1976/2,753 grt.).

Above: Arezzo, 1986, 185 grt. 33.3 × 8.3 m. 10 knots.
b. James & Stone Limited, Brightlingsea. Yard No. 527.
Ministry of Defence.
Arezzo is a landing craft that was completed in March 1987. She was advertised for sale by the Ministry of Defence in July 2014, located at Gunwharf Jetty, Sea Mounting Centre, Marchwood, Southampton. *Arezzo* is one of the nine ramped crafts operated by 17 Port and Maritime Regiment of the Royal Logistic Corps. One of their first roles was to provide logistical support during the setting up of the garrison in the Falkland Islands, immediately after the Falklands conflict. They are all being withdrawn from 2015.

Below: Jetliner, 1996, 4,563 grt. 95 × 17.8 m. 35 knots.
b. Halsnoy Verft, Halsnoy, completed by Mjellem & Karlsen, Bergen.
P&O Irish Sea services.
She was on charter to P&O Irish Sea services and was able to carry up to 577 passengers and 160 cars or 12 coaches and 55 cars on the Larne–Cairnryan service. She was replaced by *Superstar Express* on the route.

Above: 150 Years of P&O postcard.

Below: *Balmoral*, 1949, 688 grt. 62 × 8.8 m.
b. Thornycroft Limited, Woolston. Yard No. 4120.
Waverley Steam Navigation Company Limited.
She was delivered to the Southampton, Isle of Wight & South of England Royal Mail Steam Packet Company Limited and was registered as owned by P&A Campbell Limited in 1979. She was sold to Craig Inns Limited in 1983, Helseam Limited in 1985 and the Waverley Steam Navigation Company Limited in 1995.

Above: Westwood Ho, 1939, 622 grt. 60.8 × 9.2 m.
b. Thornycroft Limited, Woolston. Yard No. 1180.
She was launched as *Vecta* on 14 July 1938 for the Southampton, Isle of Wight & South of England Royal Mail Steam Packet Company Limited. She was sold in 1966, became *Westward Ho* and was converted to a floating restaurant in 1973. She was deleted from Lloyd's Register in 1993.

Below: Stena Traveller, 1991, 18,332 grt. 154 × 24.3 m.
b. Bruces Shipyard, Landskrona, completed by Fosen MV, Rissa.
Stena Line.
She became *TT Traveller* in 1992, *Stena Traveller* in 1995, *TT Traveller* in 1996, *Stena Traveller* in 2002, *Lisco Patria* in 2004 and *Patria Seaways* in 2012.

Above: P&OSL Provence, 1983, 15,811 grt. 152.2 × 28.5 m. 19 knots.
b. Ch. du Nord et de la Mediterranée, Dunkirk. Yard No. 310.
Stena Line.

She was launched as *Stena Jutlandica* on 22 December 1980 and became *Stena Empereur* in 1996, *P&OSL Provence* in 1998, *PO Provence* in 2002, *Pride of Provence* in 2003, and *Alkmini A.* and *Pride of Telemark* in 2005. She was beached at Alang on 27 October 2011 and broken up by Chaudhary Industries.

Below: Princess Marie Christine, 1975, 5,543 grt. 118.42 × 19.99 m. 22 knots.
b. Cockerill-Ougree, Hoboken. Yard No. 878.
Belgium Marine Transport Authority.

73

Above: *Princess Beatrix*, 1958, 4,668 grt. 102.2 × 18 m. 23 knots.
b. J&K Smit, Kinderdijk.
Zeeland Shipping Company Limited.
She was delivered for the Hook of Holland–Harwich service. and was normally on the day service with British Rail providing the overnight vessel. She was broken up in 2003.

Below: *Pride of Rathlin*, 1973, 4,981 grt. 117.5 × 19.5 m.
b. IHC Gusto, Schiedam.
P&O Irish Sea services.
She was launched on 22 October 1972 as *Free Enterprise VII* for the company's cross-Channel services from Dover. She was renamed *Pride of Walmer* in 1988, *Pride of Rathlin* in 1992 and *BSP III* in 2000.

Above: *Tor Gothia*, 1971, 4,128 grt. 136.8 × 21 m.
b. Framnaes, Sandefjord. Yard No. 178.
Tor Line.
She was delivered on 5 November 1972 and lengthened in 1977 (163.5/12,259 grt.). She became *Ulusoy-6* in 2004 and arrived at Aliaga on 6 January 2014 to be broken up by Sok GS.

Below: *Old Caledonia* (1934/623 grt.) berthed on the Thames at the Victoria Embankment, London. She became a restaurant ship in 1970 and suffered a serious fire on 27 April 1980.

Above: *Tattershall Castle* (1934/556 grt.) also berthed at London's Victoria Embankment. She arrived on the Thames in 2011 and operated as a floating restaurant.

Below: *Manxman* in Waterloo Dock, Liverpool.
Manxman, 1955, 2,495 grt. 105.11 × 15.24 m. 21 knots.
b. Cammell Laird & Company Limited, Birkenhead. Yard No. 1259.
Isle of Man Steam Packet Company Limited.
She was launched on 8 February 1955 for the Steam Packet's Irish Sea services to the Isle of Man. She operated her final voyage on 4 September 1982, was sold to Marda (Squash) Limited and sailed to Preston on 3 October. She was towed from Preston to Liverpool in 1990 and to Hull in 1994. In 1997, she was towed to Sunderland, where she sank at her berth in 1999. She was later moved to a covered dry-dock at Pallion Engineering, where she was broken up in 2012 by G. O'Brien & Sons.

Above: Liverpool Pier Head with *Saint Colum 1* (1973/5,285 grt.), *Leinster* (1981/6,807 grt.) and *Ben My Chree* (1966/2,762 grt.).

Below: Cicero, 1978, 5,108 grt. 147.2 × 22.5 m.
b. Smith's Dock Company Limited, South Bank. Yard No. 1338.
Ellerman's Wilson Line.
She was launched on 10 March 1978 and delivered in August that year. She became *Aegean Fantasy* in 2006, arrived at Aliaga on 10 July 2014 and was broken up by Oge GS.

Above: *Stena Forwarder*, 2001, 25,000 grt. 186.5 × 25.6 m.
b. Visentini, Porto Viro. Yard No. 195.
Stena Line.
She was launched on 28 October 2000 and employed on the Holyhead–Dublin route. She was sold in 2003 and renamed *California Star*.

Below: *Whithaven*, 1972, 1,210 grt. 66.2 × 11.5 m.
b. Appledore Shipbuilding Company, Appledore. Yard No. 88.
John H. Whitaker (Tankers) Limited.
She was launched as *Caernarvon* on 24 June 1972 and became *Shell Director* in 1979, *Frank C* in 1993, *Whithaven* in 1994 and *F. K. Badmus* in 2004. She was lost on 14 February 2010.

Above: *Eyrarfoss*, 1978, 1,599 grt. 105.6 × 18.8 m.
b. Frederikshavns Vft, Frederikshavn. Yard No. 378.
Eimskip.
She was launched on 14 October 1978 as *Mercandian Importer II*, became *Eyrarfoss* in 1980, lengthened in 1984 (118.7 m/1,864 grt.) and became *South Coast* in 1989, *Cala Fustan* in 1990, *Lucia B.* in 1999, *Jigawa II* in 2007, *Samsun Express* in 2010 and *Amazon* in 2014.

Below left: *Curran*, 1967, 1,325 grt. 69.9 × 11.1 m.
b. Boeles Shipyard, Bolnes. Yard No. 1026.
Shamrock Shipping Company Limited.
She was launched on 7 January 1967 as a containership, converted to a general cargo ship in 1979 and became *Estlandia* in 1980, *Unity II* in 1989, *Sea 1* in 2001, *Delfini XIV* in 2002 and *Captain Dimitris* in 2003. She arrived at Alaiga on 10 July 2014 and was broken up by Gemi Geri Donusum.

Below right: *Merchant Brilliant*, 1979, 2,996 grt. 133.1 × 21.7 m.
b. Vaagen, Kyrksaeterora. Yard No. 43.
Norse Merchant Ferries.
She was launched as *Norwegian Challenger* and renamed *Jolly Bruno* in 1982, *Merchant Brilliant* in 1993 and *Zoya* in 2008.

Above: *Stena Leader*, 1975, 3,484 grt. 125 × 19.1 m. 17 knots.
b. Sietas, Neuenfelde. Yard No. 756. Stena Line.
She was launched as *Buffalo* on 6 January 1975, lengthened in 1988 (141.8 m/10,987 grt.), lengthened again in 1998 (156.5/12,879 grt.), became *European Leader* in 1998, *Stena Leader* in 2004 and *Anna Marine* in 2011. She arrived at Aliaga on 9 February 2014 and was broken up by Kursan GS.

Left: Blackrock (1989/1,646 grt.) and *Crescent Highway* (1981/1,599 grt.).
Blackrock was delivered in April 1989, became *Whitdawn* in 2007 and *Golfa 1* in 2011. *Crescent Highway* was built as *Esso Avon*, became *Petro Avon* in 1994, *Crescent Highway* in 2001, *Cap Farina II* in 2005 and *Shujaa 5* in 2006. She arrived at Gadani Beach on 19 April 2010 to be broken up.

Above: *Whitdale*, 1970, 784 grt. 61.2 × 10 m.
b. Appledore Shipbuilding Company, Appledore. Yard No. 72.
John H. Whitaker (Tankers) Limited.
She was launched as *Cordene* on 22 April 1970, lengthened in 1972 (69.8 m/918 grt.), became *Pass of Chisholm* in 1975, *Danae* in 1984, *Whitdale* in 1988, *Doverian* in 1994, *Vastsjo* in 1996 and *Spindelero* in 2006.

Below: *Clansman*, 1998, 5,499 grt. 101 × 16.7 m. 16 ½ knots.
b. Appledore Shipbuilding Company, Appledore. Yard No. 174.
Caledonian MacBrayne Limited.
She was delivered in June 1998 to replace *Lord of the Isles* on the Oban–Coll and Tiree and Oban–Castlebay and Lochboisdale service. She was also the winter relief ship on the Stornoway, Tarbert, Lochmaddy, Mull, Islay and Brodick routes.

Above: *Isle of Lewis*, 1995, 6,753 grt. 101.3 × 18.5 m. 18 knots.
b. Ferguson Shipbuilding Company, Port Glasgow. Yard No. 608.
Caledonian MacBrayne Limited.
She was delivered in July 1995 for the Ullapool–Stornoway route.

Below: *Hebrides*, 2001, 5,506 grt. 99.4 × 16.3 m. 16 ½ knots.
b. Ferguson Shipbuilding Company, Port Glasgow. Yard No. 708.
Caledonian MacBrayne Limited.
She was delivered for the Uig–Tarbert and Uig–Lochmaddy services.

Above: *Finlaggan*, 2011, 5,626 grt. 89.9 × 16.39 m.
b. Remontowa Gdanska, Gdansk. Yard No. 2027.
Caledonian MacBrayne Limited.

Below: *Isle of Mull*, 1988, 4,719 grt. 90.1 × 16.31 m.
b. Appledore Ferguson Shipbuilders Limited, Port Glasgow. Yard No. 572.
Caledonian MacBrayne Limited.
She was launched on 8 December 1987, and in March 1988, it was discovered that she was over deadweight by approximately 100 tonnes. This reduced her capacity, and the company refused to accept her delivery. Various adjustments were made, and she was chartered to Caledonian MacBrayne for the summer season. It was decided that the ship would need to be lengthened for the problems to be resolved. In October 1988, she arrived at Tees Dock and was lengthened by 5.4 m. forward of the funnel. In 1993, she was employed on Oban–Craignure and Oban–Kennacraig–Port Askaig–Colonsay service.

Above: *Norbay*, 1994, 17,464 grt. 166.8 × 23.9 m. 22 knots.
b. Van der Giessen de Noord, Krimpen a/d Ijssel. Yard No. 962.
P&O Irish Sea services.
She was launched on 13 November 1993 for North Sea Ferries Hull–Rotterdam service. In January 2002, she was transferred to P&O's Irish Sea services Liverpool–Dublin route.

Below: *European Ambassador*, 2000, 24,206 grt. 170.5 × 25.8 m. 25 knots.
b. Mitsubishi Limited, Shimonoseki. Yard No. 1068.
P&O Irish Sea services.
She was delivered for the Liverpool–Dublin route. She was sold to Stena Line in 2004 as *Stena Nordica* and to DFDS Seaways in 2015 as *Malo Seaways*.

Above: Koningin Beatrix, 1986, 31,189 grt. 161.8 × 27.6 m. 20 knots.
b. Van der Giessen de Noord, Krimpen a/d Ijssel. Yard No. 935.
Stena Line.
She was delivered in April 1986 as *Koningin Beatrix* and renamed *Stena Baltica* in 2002 and *SNAV Adriatico* in 2013.

Below: Seacat Isle of Man and *Stena Lynx III*.
Seacat Isle of Man (1991/3,003 grt.) was built as *Hoverspeed France* and became *Sardegna Express* in 1992, *Hoverspeed France* again later that year, *Seacat Boulogne* and *Seacat Isle of Man* in 1994, *Seacat Norge* in 1996, *Seacat Isle of Man* again in 1997, *Sea Express 1* in 2005, *Snaefell* in 2007 and *Master Jet* in 2012.

Stena Lynx III (1996/4,113 grt.) became *Elite* in 1998, *Stena Lynx III* in 1999, *Elite* in 2003, *Stena Lynx III* again in 2004 for service on the Fishguard–Rosslare route and *Sunflower 2* in 2012.

85

Above: *Superseacat Two* (1997/4,462 grt.) and *Emeraude France* (1990/3,012 grt.) at Douglas, Isle of Man.

Below: *Seacat Diamant*, 1996, 4,305 grt. 81.2 × 26 m.
b. Incat Limited, Hobart, Tasmania. Yard No. 041.
Sea Containers Limited on charter to the Isle of Man Steam Packet Company Limited.
She was built as *Holyman Express* and became *Holyman Diamant* in 1997, *Diamant* in 1998, *Seacat Diamant* in 2004 and *Jaume III* in 2007.

Above: Testing the emergency life-saving equipment on *Seacat Isle of Man* at Birkenhead.

Below: *Wincham*, 1949, 201 grt.
b. Yarwood Limited, Northwich. Yard No. 816.
Wincham was the last example of the final generation of Weaver packets, small coasters owned by Imperial Chemical Industries Limited, which operated on the River Mersey and the Manchester Ship Canal. She is seen here on her last voyage when she was sold and broken up in 2009.

87

Above: *Riverdance*, 1977, 1,599 grt. 116.3 × 18.2 m.
She is seen on the beach at Blackpool in 2008. She was built as *Mashala*, becoming *Halla* in 1986, *Tikal* in 1988, *Schiaffino* in 1989, *Sally Eurobridge* in 1993, *Eurobridge* and *Sally Eurobridge* in 1994 and *Riverdance* in 1996. On 31 January 2008, her engines failed, and she was driven ashore at North Shore, Blackpool where she was later demolished.

Below: *Clipper Point* (2008/14,759 grt.) and *Seatruck Progress* (2011/19,722 grt.) pass in the River Mersey off New Brighton. They were both employed on Seatruck's Liverpool–Dublin service.

Above: Arklow Marsh, 1988, 1,523 grt. 73.9 × 11.8 m. 11 knots.
Hugo Peters, Wewelsfleth. Yard No. 636.
James Tyrrell Limited, Arklow Shipping Limited.
She was renamed *Fehn Trader* in 2004, *Torill* in 2006, *Vagsund* in 2011 when she was converted to a fish farm support vessel (1,732 grt.).

Below: The Airbus factory is located at Broughton, 15 miles from Mostyn on the River Dee. The factory manufactures wings for the Airbus range of aircraft which are exported to the final assembly at Toulouse in France by special aircraft. However, the wings for the A380 airliner are too large for the aircraft and are exported by sea. They are brought to the Port of Mostyn by the *Afon Dyfrdwy* and are loaded onto a roll on/roll off vessel, which takes them to Bordeaux, where they are transferred to river craft and delivered to Toulouse via the River Gironde.

Above: *Liverpool Viking*, 1997, 21,856 grt. 186 × 25.6 m.
b. Visentini, Porto Viro. Yard No. 182.
Norfolk Line.
She was built as *Lagan Viking* and became *Liverpool Viking* on 2005 and *Liverpool Seaways* in 2010.

Below: *Hibernia Seaways*, 1996, 13,017 grt. 142.5 × 23.5 m.
b. MIHO, Shimizu. Yard No. 1460.
DFDS Seaways.
She was launched on 1 July 1996 as *Maersk Importer* and became *Hibernia Seaways* in 2010 and *Stena Hibernia* the following year.

Above: *Stena Britannica*, 2003, 43,487 grt. 210 × 30 m.
b. Hyundai Limited, Ulsan. Yard No. 1392.
Stena Line.
She was launched on 31 May 2002 as *Stena Britannica II*, became *Stena Britannica* in 2003, lengthened in 2007 (240.1/55,050 grt.) and became *Britannica* in 2010, *Stena Scandinavica IV* and *Stena Scandinavica* in 2011.

Below: *Stena Adventurer*, 2003, 43,532 grt. 210.8 × 29.9 m.
b. Hyundai Limited, Ulsan. Yard No. 1393.
Stena Line.
She was delivered on 16 May 2003 for the Holyhead–Dublin service.

Above: *Isle of Arran*, 1984, 3,296 grt. 84.92 × 16.24 m. 15 knots.
b. Ferguson-Ailsa Limited, Port Glasgow. Yard No. 491.
Caledonian MacBrayne Limited.
She was launched on 2 December 1983 and sailed on her maiden voyage on 7 April 1984 from Ardrossan to Brodick. In 1993, she was replaced by *Caledonian Isles* and transferred to the Kennacraig–Islay route.

Below: *Portaferry II*, 2002, 312 grt. 38.2 × 14.6 m.
b. Gdanska SR, Gdansk. Completed by McTay Marine, Bromborough. Yard No. 127.
Strangford Lough Ferry Service (Dept. for Regional Development, Northern Ireland).
On delivery of *Portaferry II*, the *Strangford Ferry* became the reserve ferry.

Above: *European Causeway*, 2000, 20,646 grt. 159.5 × 25.7 m. 23 knots.
b. Mitsubishi Heavy Industries, Shimonoeki. Yard No. 1065.
P&O Irish Sea services.
She was delivered on 14 July 2000 for the Cairnryan–Larne service.

Below: *Wind Perfection*, 1962, 14,981 grt. 153.4 × 28.2 m.
b. Weser Seebeck, Bremerhaven. Yard No. 1031.
C-bed Limited.
She was built as *Olau Britannia*, became *Bayard* and *Christian IV* in 1990, *Julia* in 2008 and *Wind Perfection* in 2012. In December 2015, she was sold to Moby Lines.

Above: European Endeavour, 2000, 22,152 grt. 180 × 25 m., 22 ½ knots.
Ast Españoles (AESA), Seville. Yard No. 290.
P&O Irish Sea services.
She was launched as *Midnight Merchant* on 26 November 1999 and became *El Greco* in 2006 and *European Endeavour* in 2007.

Below: Stena Hibernia, 1996, 13,071 grt. 18 ½ knots.
She was built as *Maersk Importer* for the Norfolkline, becoming *Hibernia Seaways* in 2010 and *Stena Hibernia* the following year.

Above: *Seatruck Power* (2012/19,722 grt.), *Stena Lagan* (2005/27,510 grt.) and *Norbank* (1993/17,464 grt.) in the Queen's Channel, off the River Mersey.

Below: *Stena Performer*, 2012, 19,722 grt. 21 knots
b. Flensburger, Schiffbau-Gesellschaft, Flensburg. Yard No. 751.
Stena Line.
She was delivered as *Seatruck Performance* and became *Stena Performer* in 2012.

95

Seniority, 2007, 3,859 grt. 95.2 × 17.1 m.
b. Qingshan, Wuhan.
F. T. Everard & Sons Limited.
She was launched as *Superiority* and was renamed *Seniority* in 2006.